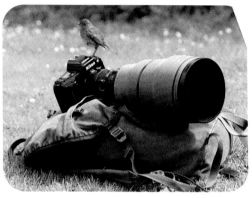

Images of Shetland
by Bill Jackson

The Shetland Times Ltd.
Lerwick
2000

Images of Shetland

ISBN 1 898852 50 2

First published by The Shetland Times Ltd., 2000.

British Library Cataloguing-in-Publication Data
A catalogue record for this book is available from the British Library.

Printed and published by
The Shetland Times Ltd.,
Prince Alfred Street,
Lerwick, Shetland ZE1 0EP, UK.

Over the past six years or so, I've recorded with the camera, some of my favourite Shetland scenes whilst travelling around these Northern Isles. Studies of everyday life, the wildlife and folk, not forgetting the spectacular settings that come in all forms throughout the seasons. Images of Shetland will be a reminder of these isles; a magical place with moods and atmospheres all of its own. Islands surrounded by ever changing seas with weather to match. Its many moods are reflected in the way events unfold in a cycle of seasons that can change day by day, if not hour by hour, but then this is Shetland.

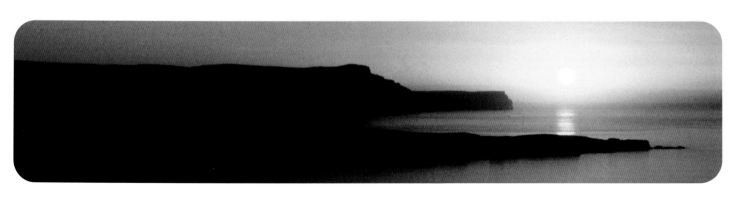

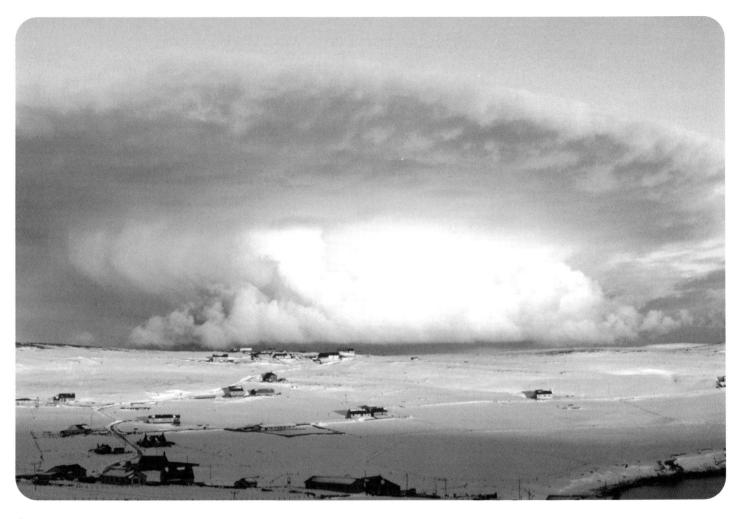

4

There's no snow like a lot of snow...winter 1996

Every now and then Shetland has a real snow fall; one to remember. Storms that disrupted life for many came during the Christmas of 1996. It had been about forty years since the last big fall and those who remembered it said that due to the traditional way of living then they were able to cope without too much bother. Today's living style was hit badly for several days. No electrical power to the more modern homes meant an almost total lack of heating and lighting – a big problem that simply did not arise some forty years ago when most homes were fuelled by peat. Roads were blocked for days and travel restricted to four-wheel drive vehicles mainly around Lerwick. Abandoned cars caused headaches for the road clearing crews. Deep freezers were a big loss for some with almost all of the contents ruined. We resorted to burying the food under the snow in the garden!

Forgetting these human anxieties, wildlife were suffering and birds in particular eagerly awaited feeding time at each house in turn. Picturesque scenes just outside your back door. The light for photography was almost too bright. Usually at this time of the year in Shetland no one would dream of using anything other than 200/400asa film. I think some scenes could well have been taken on a slow film of 25asa comfortably. Ice formed to a thickness of four inches on the pond and it was difficult to keep a hole open for the birds who needed fresh drinking water daily. With no fish in the pond there were no worries about bashing through the thick ice.

The silence was a great experience as cars were out of action for some time. As a neighbour found out … snow gets everywhere and it took a little more than a pair of jump leads to get the engine going. Slowly Shetland life got back to normal and as back roads were opened up the beauty of the countryside could be appreciated to the full. We are close to the Arctic Circle and every now and then, nature reminds us just how life can be this far north. Wildlife has to adapt and folk living here had a harsh lesson to remember for future winters.

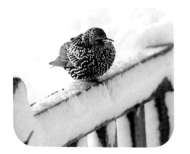
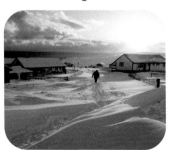
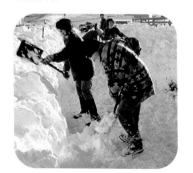
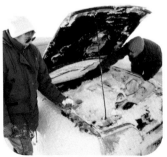

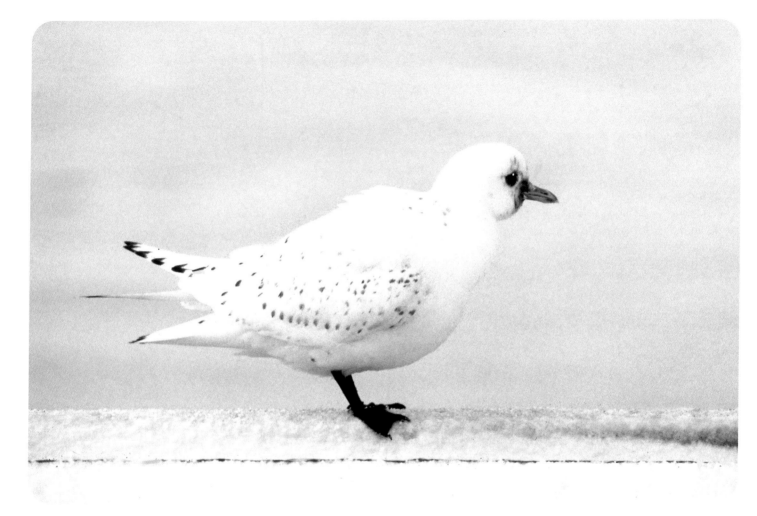

Have you ever seen so many gulls?

Wandering around the harbours of Shetland the numbers of gulls that gather, waiting for the next fishing boat to arrive and unload, are impressive. On occasions a vessel will return from a trip north and bring back a rare gull in its wake. Iceland, glaucous and the most beautiful of all, the ivory gull. Others such as a Ross's, little, Sabine's, Kumlien's, ring-billed, Mediterranean, Bonaparte's and laughing gull have been added to the list over the years.

The sheer numbers of resident herring and great-black backs that fly about in huge numbers by the Shetland Catch fish processing factory are impressive. During stormy times, with gale force winds from the north some of the more exotic sea birds can be found around these shores. As you can see there's more to sea gulls if you take a close look at them. Often a creamy white first winter Iceland or glaucous can be found around Lerwick and Scalloway harbours.

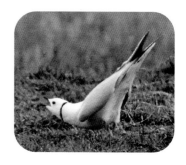

Others such as the ring-billed or little gull take a bit more finding but they are there at times, and with luck an exciting one will come your way. Throughout the season around 80 combinations of species and plumage can be found to test your identification skills to the limits. Many are easy to identify but not the Kumlien's gull – a sub-species of the Iceland – which can be found in the most unlikely of places, the last one I photographed was outside the Co-op in Lerwick. Gulls can turn up almost anywhere. I'm looking forward to the next ivory or another Ross's: real stunners and all the way from the high Arctic to visit Shetland.

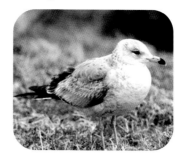
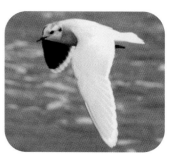

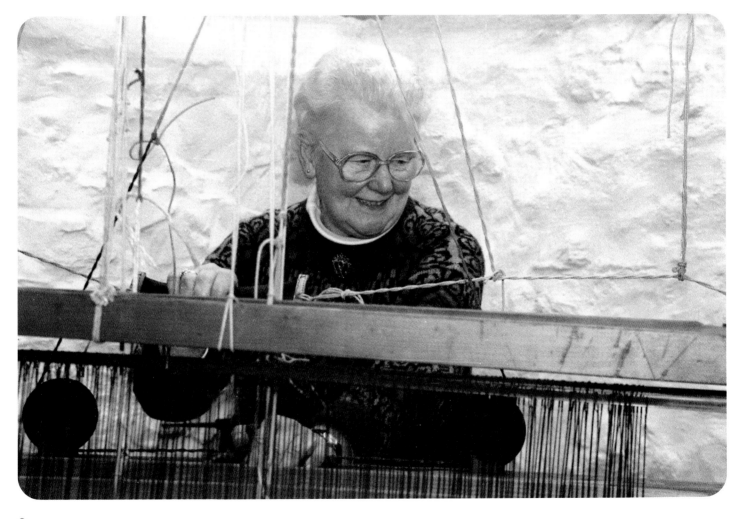

Quality crafts using tools of the past with skill...

For many generations local folk spent their long winter evenings by peat fires working with effortless skill producing real quality crafts. Just how many hours, or indeed years of practice goes into the making of a christening shawl or an elaborate hand woven cloth is beyond imagination.

Today these traditional crafts have been revived and many new skills are being practiced throughout the isles. Furniture that would grace any home and will last for count-less generations. Spinning wheels pottery, jewellery, rugs, Shetland yoal building and some folk still have the ability to rebuild an old sail herring drifter called the *Swan*. Now there's a real sailing boat!

Producers of Shetland woollen garments have a tremen-dous reputation world-wide for quality. There is no substitute for the original handmade genuine article.

There are some fine examples of Shetland's crafts that you can't take with you, but come and take a look at them for yourself. Throughout the isles you can see stone dyking that's built to last forever. If you want the real thing this is the place, with our weather there can't be half measures, it would not last and this is where the quality pays off.

There are many artists who capture the feel of the place on canvas, paper, stone and wood, with words and even sound. Many books have been written about these islands and cover all aspects of life both past and present. Shetland crafts have been revived. Good tools from times gone by are never discarded, like the skills themselves, saved, cherished and handed down to the crafts men and women of today to use creatively as always.

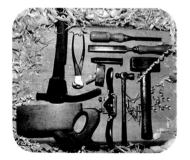

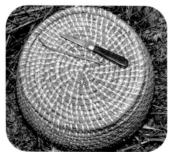

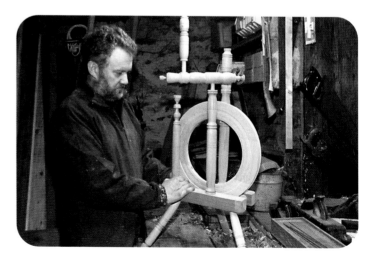

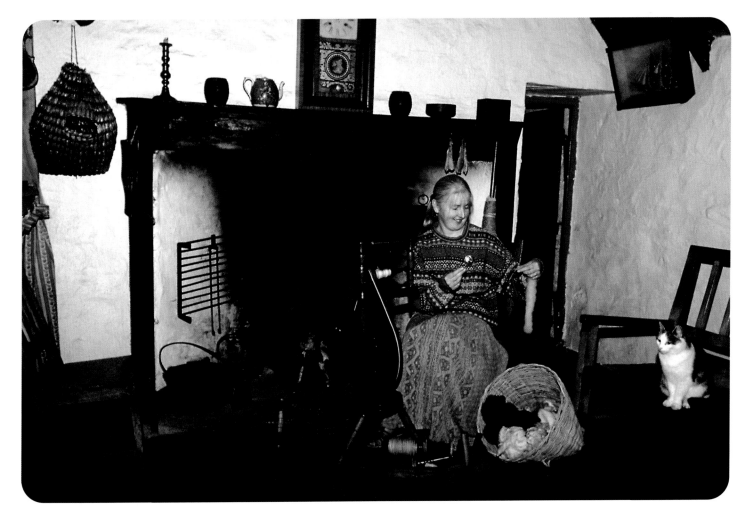

It takes years of practice to be this good at it...

Weaving, spinning and knitting are traditional skills of these northern isles. There are of course many copies of the originals all over the world, but the real Shetland item can only come from these shores. The quality and style can not be copied without the generations of experience that goes into each and every garment. Patterns that have been developed and designed here in Shetland are known throughout the world as the very finest available with a long lasting, hard wearing quality. Anne Eunson (left) spins whilst her sister Kathleen Anderson (below) knits the fine cob web shawl. Young Debbie Wynn looks on in wonder as the next delicate piece of work takes shape. Weighing only a few ounces the completed shawl will be treasured by a lucky family.

To watch a skilled spinner make the wool for a fashionable sweater or fine lace knit shawl is indeed to watch pure ability that comes from years of practice. Hours spent patiently working at the wheel or clicking away with a really fine pair of knitting wires. Various craft shows display the finest work in all shapes and forms; traditional along with modern introductions. Young, stylish and trend setting ranges from Shetland stand out from the crowd. Applying up-to-date skills with traditional materials to make a fashion statement far removed from the traditional styles of old. Many have tried to copy the original but only the very best comes from Shetland.

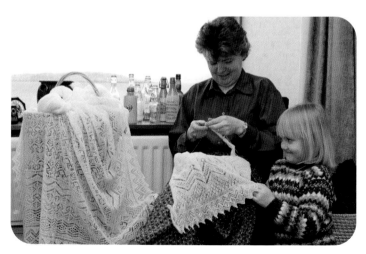

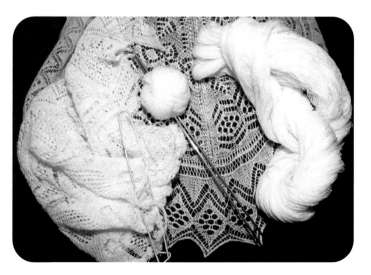

11

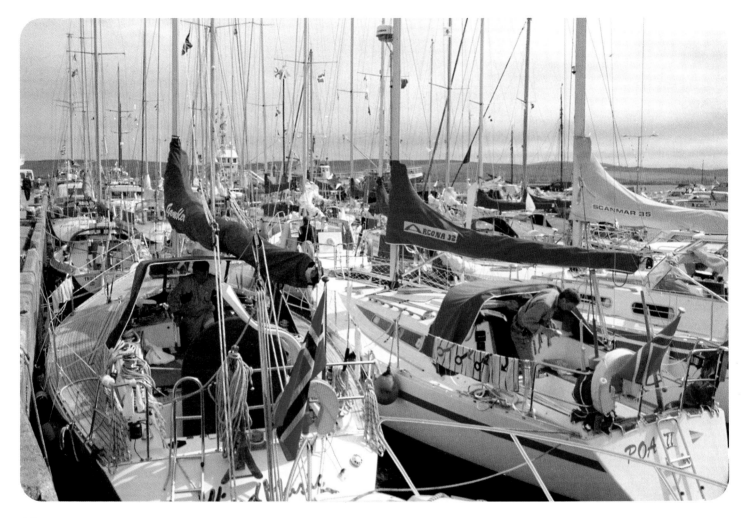

The Shetland Race
for colour and more colour...

When the Norwegian yachts arrive in Lerwick Harbour during the Shetland Race in May, the sheer splash of colour grows by the hour till the whole area is awash with flags and yachts of all shapes and sizes. In 1997 the race coincided with Norwegian National Day and a large flotilla of cabin cruisers and luxury high speed launches accompanied the race. The town took on a carnival atmosphere as friendships were renewed as locals turned out to admire the scene. Traditional costumes were a big part of the event and the finely embroidered garments were worn with pride.

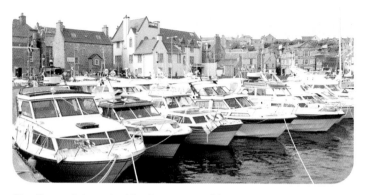

For those interested in the sea and boats not to mention all the traditional festivities involved especially during National day then this was a week to remember.

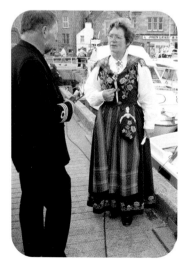
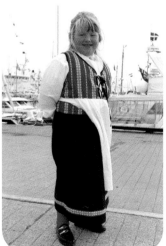
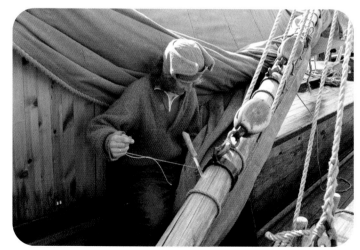

13

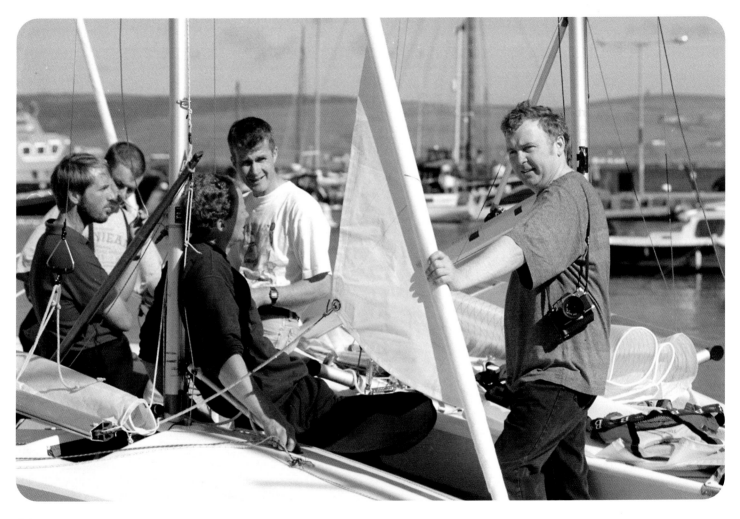

Snapping the pro's can be easy when the boats are in...

Shetland has many distinguished photographers and there's nothing like a harbour full of visiting yachts to bring them out in force. For sheer colour and atmosphere Lerwick harbour has few rivals. The professional and amateur alike have a feast of subjects to snap away at. Boats of course, but then there's the folk who are just as interesting and can make a picture complete. At a break at the dinghy races leaves crews chatting to local cameraman Malcolm Younger as he waits to capture any action (left).

Waiting with his eye on something else is Dennis Coutts (right) who also has to be patient. Sometimes the photography is not all action packed and that's my chance to capture them doing their thing.

Shetland is well catered for by way of camera and processing shops, but I can't help wondering how long it will be before the digital era takes over and our film eating contraptions will eventually bite the dust. At least dust and scratches will be a thing of the past once the new systems are perfected. I'm sure its only a matter of time.

For now I find that the new still has a long way to catch up to the old for the best results. I am convinced that it will be a great advancement, combined with computers and printers there will be virtually have no boundaries. Leaving your imagination and creativity to run wild without all the costs and time delays that are associated with present day methods.

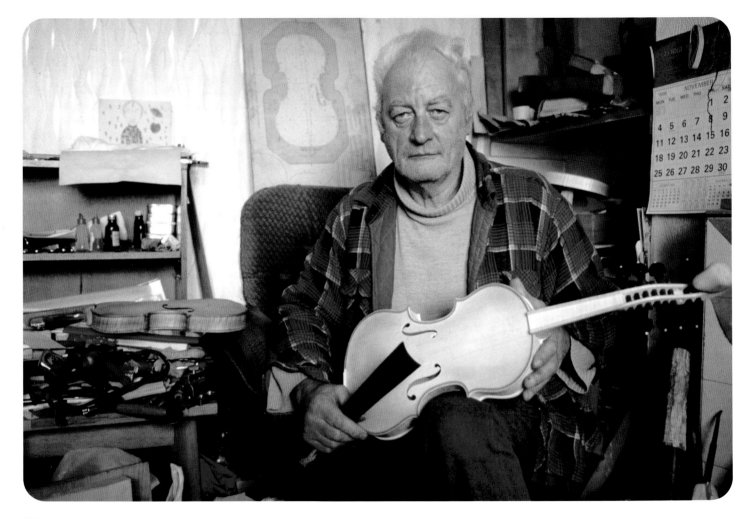

Fiddles ancient and modern crafted with real style...

Shetland fiddle makers create instruments of quality in well tried styles of old … then there are also the new exciting breed of fiddles that have taken many years to design and perfect. Whether the fiddle design is new or old the skill involved only comes with practice and more practice. The late Peter Gray of Lerwick (left) used to make eight string Norwegian Hardangers using the simplest of tools and the finest of woods available. A real Shetland craftsman using ability and traditional skills.

Today we have the latest technology along with imagination to make a newly designed instrument for the future. The Skyinbow electric fiddle is now internationally acclaimed and played by many top artists. A traditional instrument improved to suit todays musicians by Kenny Johnson (right) seen here with his Pro Active model. Watch for them on TV. What is it they say … many a good tune is played on an old fiddle, how times have changed. Shetland crafts and skills move on.

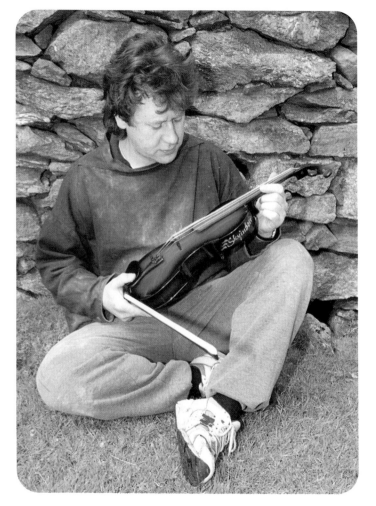

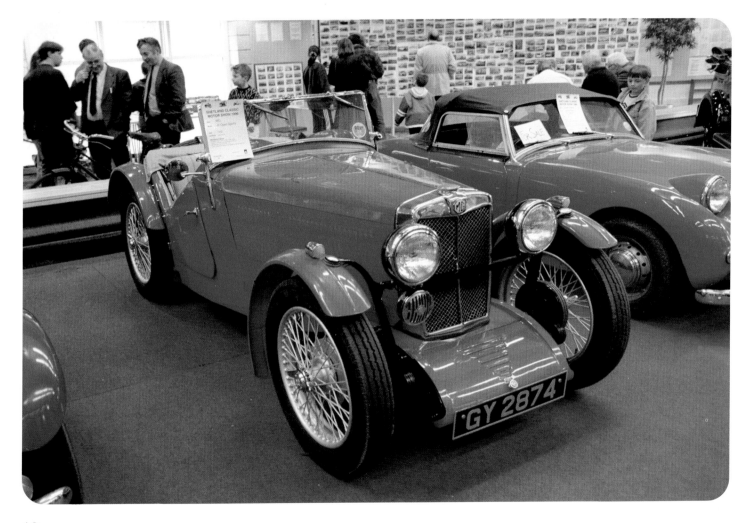

Mechanical wonders at the Classic Motor Show ...

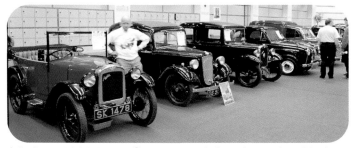

Every two years the wonderful machinery of times past are on display at the Clickimin Leisure Centre. Cars dating back to the 1920's lovingly restored to pristine condition with photographic histories of the work involved proudly on show. Makes from most leading manufacturers of their day with small but beautiful examples of Austin or Morris right through to beauties of perfection in engine and coach work. Sports cars such as the MG (GY 2874) and the J2 open sports 847cc of 1932 stole the show for me. It almost took my mind off the bikes! A collection of motorcycles for any enthusiast to drool over. Gleaming models from the earliest combinations to the very latest flying machines. Although my preference is for the German flat twin of BMW fame usually there's a good number of British makes to see. Names such as BSA, Norton, Triumph, Royal Enfield, Ariel, AJS and who could not mention the fine 1932 Rudge Radial or the fabulous 1934 350cc Scott tourer. It is quite noticeable how the motorbike has progressed from a gentle 2.5 hp to the modern high powered beasts that are on offer today. The latest road burners are at the show with a number of Japanese technological dream machines to drool over.

Land Rovers are there in force from the earliest bone shakers right up to today's huge models with every comfort for the off road enthusiast or shopper to enjoy. Is it still the old work horse or has the image changed just a wee bit?

Whatever your taste, the 400 plus exhibits at the Classic Motor Show are a delight.

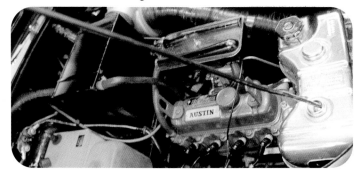

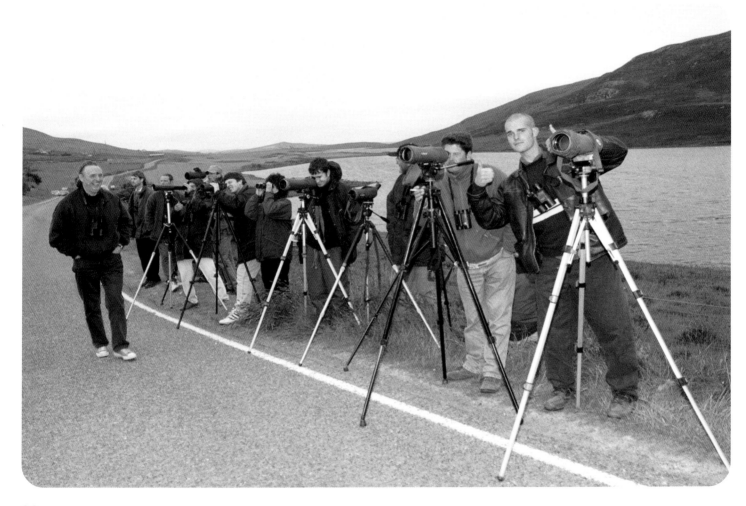

A what? ...
A blue-cheeked bee eater

Extremely rare birds often put in an appearance on these northerly isles. When the blue-cheeked bee eater took up residence in a garden at Asta, keen birders from south made a frantic dash to Shetland. Will it stay on for a while, is it still there? Phones were hot until the excited groups started to arrive and saw the splendid bee eater for themselves. One or two unfortunate folk missed the bird as it disappeared from time to time, but being a determined lot they made the trip again, one lad all the way from Norfolk, that's a keen birder for you and as it turned out, a very happy one.

Some saw several other rarities during their fleeting visit, five more in all, so what a tremendous trip to remember. Anthony Brydges, Chris Jackson, Chris Batty, Andy Adcock and top bird photographer Rob Wilson are folk that made the experience a special one, as the time was passed with tales of other twitches.

Enthusiasm came by the bucketful and those who were only names on a list are now friends and will no doubt make several trips to see Shetland's rare birds in future.

Locals around Tingwall had good views of the bee eater as it perched on Brian Anderson's washing line or on its favourite sycamore tree in Janet Leask's garden. This was a first for Shetland and Scotland and a more colourful bird would be hard to imagine. What will turn up next is anyone's guess.

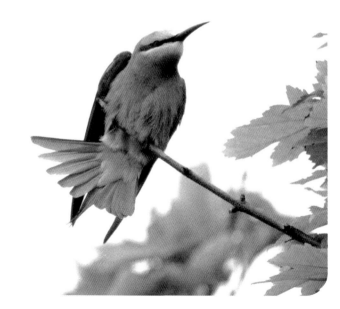

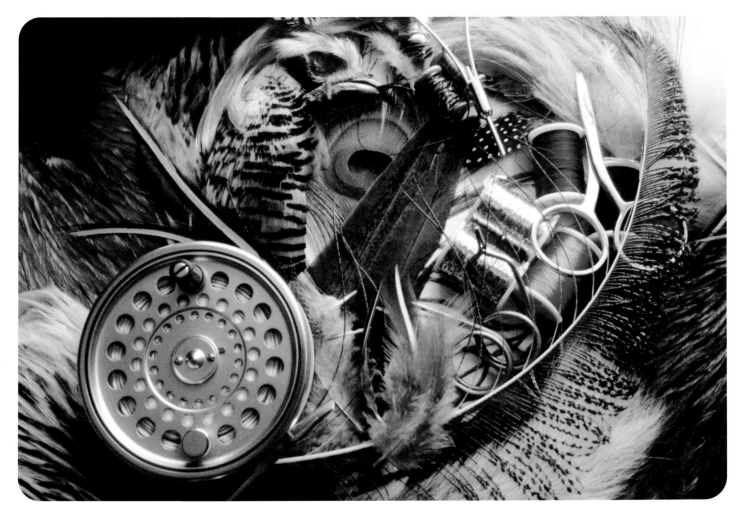

Come the trout season and winter has long gone...

The season ahead is in the thoughts of Shetland's trout anglers as many a gloomy winters evening will have been be spent creating fly dressings. New designs, old favourites, or just the first fumbling attempts at a pattern seen in a fly box at a loch side as a successful angler unhooks another beauty. This is the very fly that will make all the difference next season!

Fly secrets are normally handed down in fishing circles, it's where to find the fish that causes most problems. For no apparent reason a friend will return from a hill loch with a good bag and you will fish on into the gloom wondering when it will be your turn to boast. This is partly what keeps fishermen interested, the challenge, the frustrations and a determination to catch a good fish. Of course you enjoy it, why else would you face a biting cold wind and pouring rain if not for pleasure? Skills with the fly rod are only part of being a really good angler, to be able to take a fish on your own fly is the icing on the cake.

Look in a fly box and you more often than not find little to resemble a natural insect. The days of trying to imitate the nymph, spinner or dun have been replaced by beetles, baby dolls, muddlers, skimmers and bug-eyed monsters to tempt the unwary trout. They do of course take fish and occasionally large trout will fall to these spangled creations. Looking at a modern trout fishers fly box today reminds me of Christmas with all the tinsel, bright floss colours and beads.

Every water has its own way of giving up big fish and for me traditions die hard. To imitate a real fly, present it perfectly to a fairly large rising fish in a perfect Shetland setting – a secluded and remote loch – with only the birds to share your success is a dream I have yet to fulfil!

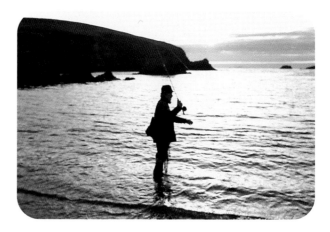

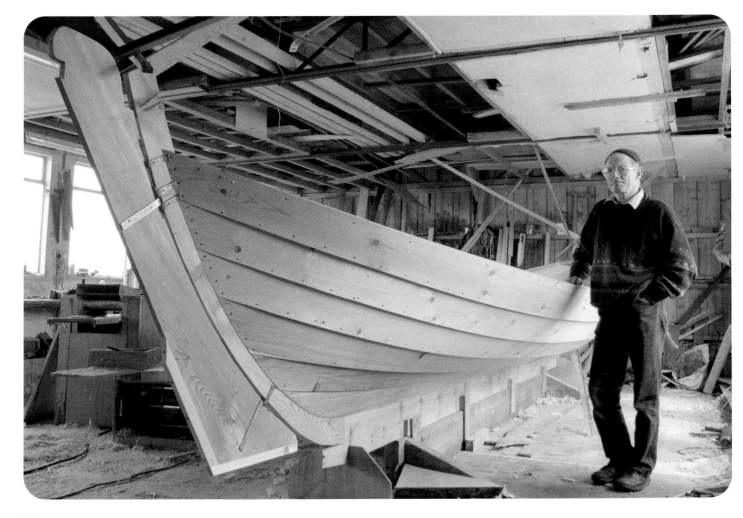

Small boats; the essential work horse of the isles...

Folk who still have the skills needed to construct a craft that will safely convey passengers over these waters can be counted on one hand today. If you have the opportunity, visit a local yoal builder and see one of the most traditional skills still practiced in Shetland today. To watch a yoal fashioned from rough wood is a marvel. Many of the old tools are still in use producing the designs and lines of the Shetland craft. Klink hammer, chisels, adze and a selection of mallets, planes and spokeshaves. There is of course a highly prized recipe for the beautiful finish to the very best of timbers. Redwood keel, larch stem, stern and planks. The revival of the yoal rowing competitions has given the Shetland boat builder a welcome boost and this in turn will guarantee the future of the much loved yoal.

Almost every outer island has a collection of long abandoned decaying boats with a long history behind them. Every boat has a wealth of tales connected to it and locals will happily recall countless trips that these extremely strong old craft have made and survived.

The sad old mail run and flit boat can be still seen lying up on Fetlar. A huge craft no doubt powered by strong local rowers in all weathers. When standing by the boat the sheer size is quite impressive, to have seen it underway loaded up would have been a sight.

How times have changed for the island folk, but the lifeline for many is still the sea. Modern ferries have helped daily living, making trips to the mainland a lot easier and depending on the state of the seas, almost totally reliable.

In the past when folk worked in a very much more fish enriched sea, it must have been a great way of life, if hard. Taking the boats out to the mackerel or herrings shoals, setting the nets and bringing in a well earned catch to fill up the salt barrels, some to hang out to dry for the winter. Salted and wind-dried saithe can still be seen around the coastal crofts today.

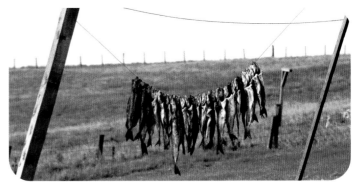

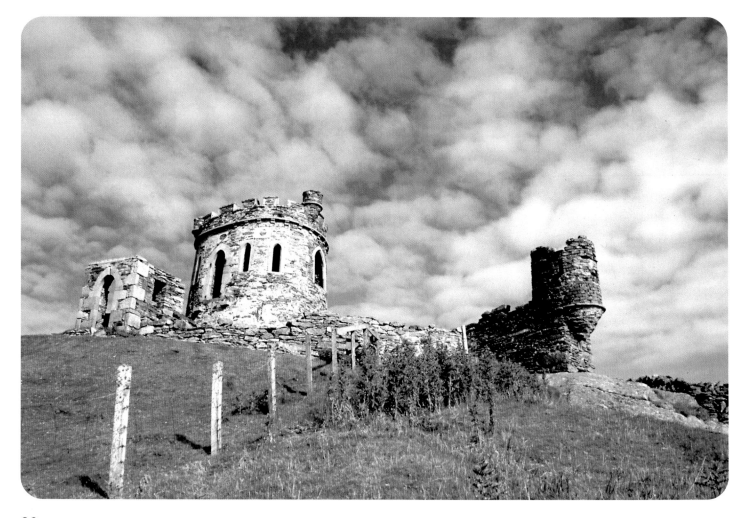

Fetlar has the neck for it; little red-necked beauties plus a few more resident breeders...

Brough Lodge on Fetlar (left) has an intriguing history and visitors make the trip to view this and to enjoy the most beautiful of isles, with unmatched scenery and real peace and quiet. But most folk go to Fetlar for the birds. Not just any bird, a very special wader that goes by the name of a red-necked phalarope. One of Shetland's rarest breeding species. Red-throated divers and golden plovers can also be seen, almost as soon as you set foot on the island. This can be one of the most rewarding islands for wildlife. Otters will watch you getting off the ferry! Wheatear, dunlin and ringed plover at the roadsides on your way to Loch of Funzie, where you will find the diminutive but incredibly trusting, red-necked phalaropes feeding around the shoreline.

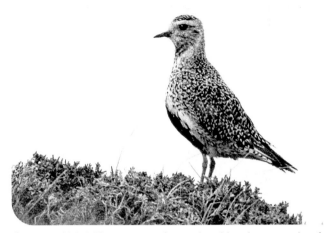

Songs of bird life are not often ruined by the sounds of cars. Only as folk commute to the next ferry will you hear sounds to remind you of city. Fetlar really is another world.

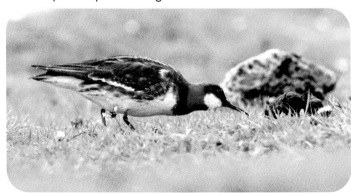

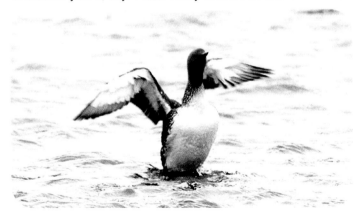

27

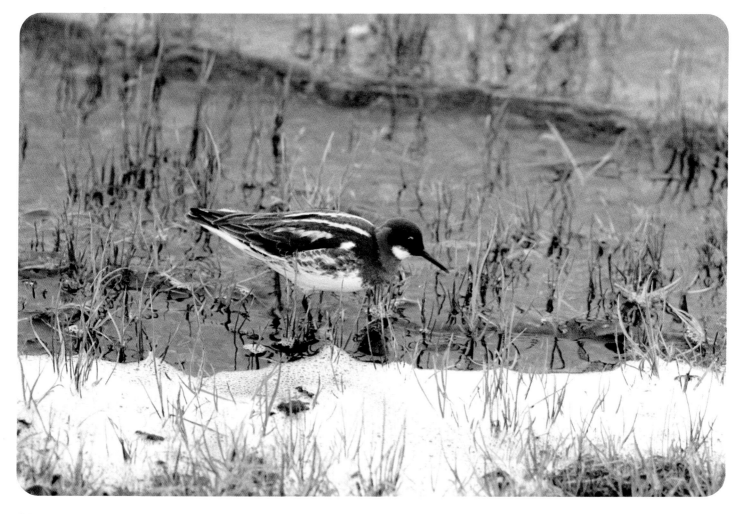

Phalaropes also bring the professional folk to Fetlar...

Over the years many wildlife programmes have been made using various locations and animals of Shetland. Otters and killer whales have been well covered but the easiest to capture on film must have been the red-necked phalaropes for the Bill Oddie series of birding programmes. At one stage Bill was being filmed by the crew only feet away from the feeding birds. However, the crew were not impressed with the cool weather, considering it was late June.

The RSPB have improved the habitat and built a substantial hide overlooking the mires where the phalaropes feed and may well breed. Most people can, however, see the birds long before they go to the hide by simply sitting quietly in the passing place at the lochside.

Many photographers are surprised when they attempt to get close up pictures of the diminutive wader, arriving with huge telephoto lenses only to end up by using shorter and shorter ones as the day progresses. Some of the finest photos that I have seen were in fact taken with a wide angle lens and show the bird taking an immerging aquatic insect from a stem as this one is. This shot was taken with an 80-200mm zoom and a fairly fast film. Another problem when working with these rapid feeders is it took me a number of films and visits before finally freezing the action. You know the pictures – a pin sharp body but a blurred bill and head – we all have them! Don't be caught out as they are really fast feeders. Just get down to their level and you will have the birds feeding within a few feet. One friend actually had a bird take a fly off his shoe … if all birds were so trusting part of the challenge would be lost.

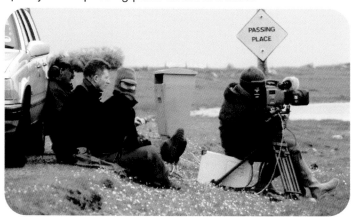

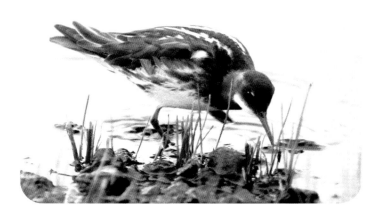

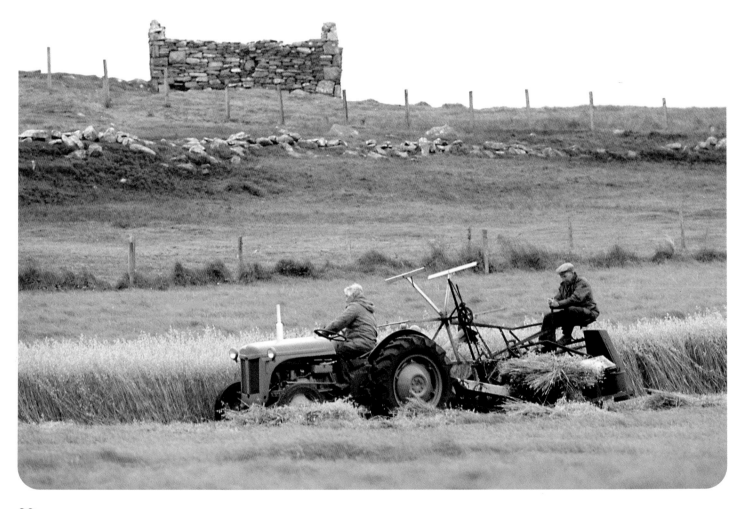

Some of the old ways still work today, especially for the birds

The working ways of a number of Shetland crofts have changed very little over the years and this pays huge dividends when it comes to the rich bird life that can be found at harvest time. Traditional methods mean that there will be food in plenty not only for the resident but also migrating birds that can find a sanctuary to feed up in on their way south.

It's at this time of the year that really rare birds can drop in on a croft, like the bobolink that was found at Durigarth. This North American bird happily took advantage of the grain and remained in the area for over a week, much to the excitement of bird watchers as another new species for their Shetland list was ticked off.

Many folk in the outer isles still cut the corn by hand when the weather is kind and this brings the past to life for many a visitor. No matter how small the fields it takes a lot of hard work. The bonus of harmful chemicals not being used means Shetland crofts can almost become wildlife reserves at harvest time.

Magnificent farming contraptions also clatter their way through the fields, machines that have seen service for more years that folk can remember. Beautiful Ferguson tractors, reapers and all manner of implements that many an agricultural museum would be proud to have on show. These are of course working tools and lovingly cared for after use, stored away for another year and will no doubt be ready to do their part in 12 months time.

This is one of the most nostalgic scenes that can be found throughout these isles and can provide the photographer with ample opportunities for unique pictures. Crofting families have many tough times but on a sunny day with a warm drying wind there's no happier place to be.

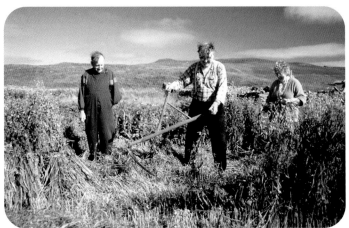

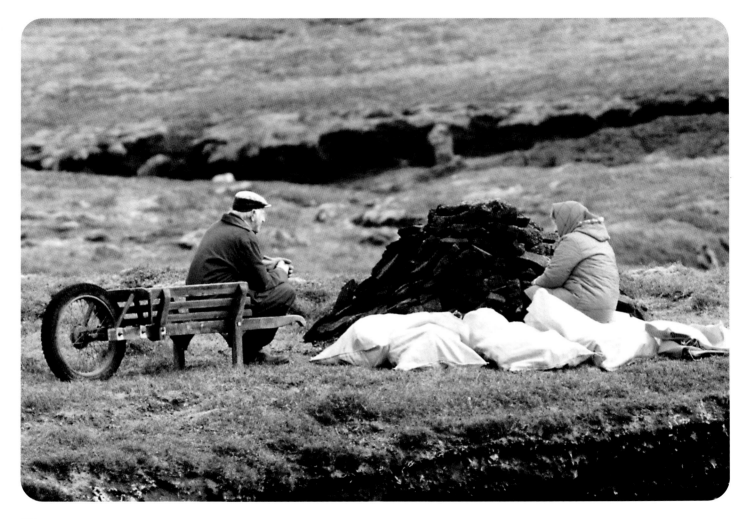

Twice the heat
if you really work hard at it...

Cutting peat, collecting and the eventual bagging up and stacking, all help to warm you long before you actually get around to burning the fuel of the islands.

Traditionally folk in Shetland have worked at peat banks handed down through their families; many are still in use today. Back breaking work with the whole family helping with the stacking and loading once the peats have dried out. It will make those cosy winters evenings by the fire seem all the more satisfying. More so when all power supplies are down during stormy times, folk can rely on their peats and continue life as normal.

Often peat workers will have Shetland bird life of the open moorland for company as they toil at the banks. Snipe and wheatear look on as a curlew calls overhead in the tranquil atmosphere of a typical and traditional way of life. If you are lucky and the weather is kind, all will appear idyllic. Enjoy it while it lasts. Shetland has many moods and it can all too quickly change without warning.

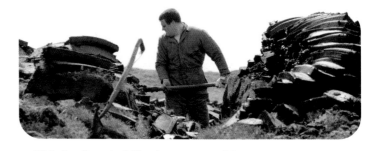

This is all part of it's character and I'm sure no-one comes to these northern shores looking for a tan! Soak it all up, weather included, it's a big part of the really wild side of Shetland. Depending on where you are working you may be fortunate to see a whimbrel but more likely to only hear it as it flies overhead. The redshank however will sit up on posts and watch every move of a great skua as it feeds on a rabbit. Moors are never as empty as they look.

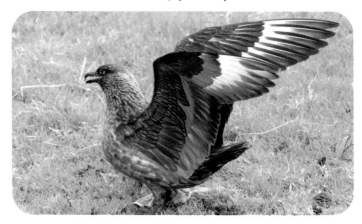

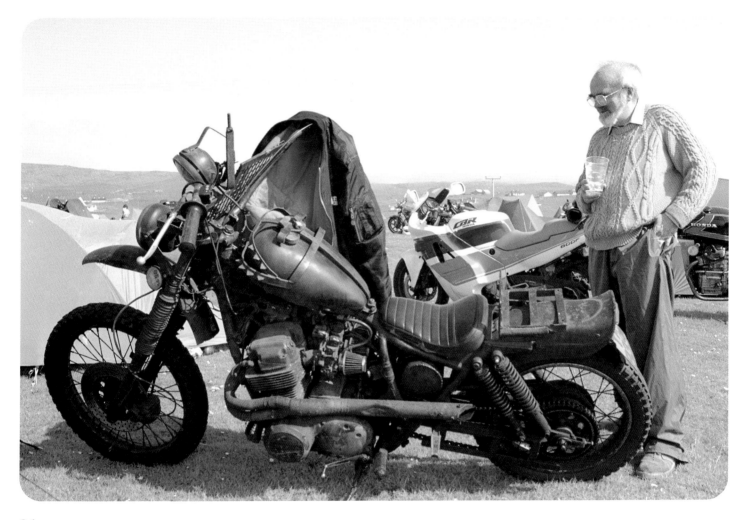

Geordie's dream machine?

Any serious biker coming to Shetland for the Simmer Dim rally in June joins quite an elite gathering – folk and bikes of all descriptions from the very latest glittering multi's to rust encrusted, oil dripping bangers – the point is they all make it to these shores and have a trip to remember. Travelling from all corners of Britain, even a number from abroad, they disembark from the ferry and gather in Lerwick. Where else would they meet other than at the Thule Bar, Lerwick.

The convoy then heads up to the camp site at Vidlin to meet up with the locals, where four days are spent partying. Entertainment includes live bands, organised bike runs, and after a few beers the party games begin!

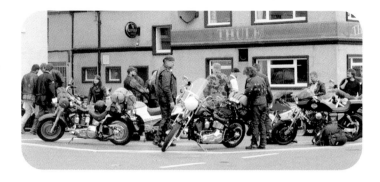

On a fine morning the bikers gather for a run down to Sumburgh. Immaculate machinery gleaming in a backdrop of a rugged Shetland landscape. Rows of two wheeled technology lined up in a colourful display of power.

Locals and visitors alike look over the very latest sports machines and discuss what they would like to move up to. Biking is what it's all about at the Simmer Dim Rally, meet you again next time.

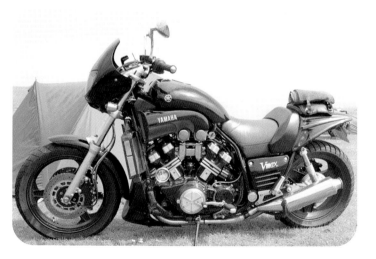

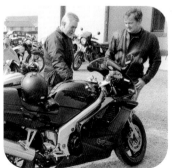

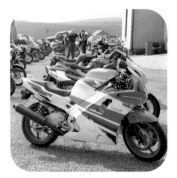

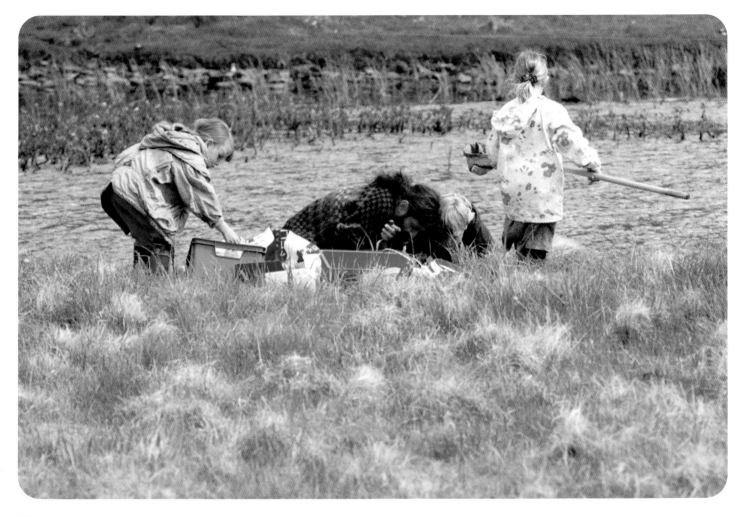

Enthusiastic budding Tulloch's, start them young Harry...

In a few years there may be a natural successor for the late Bobby Tulloch (right), a naturalist and very famous son of Shetland. Natural history has many subjects but unlike Bobby few have a sound knowledge of just about everything that walks, flies or swims around these shores. Not to mention his world-wide experiences which he has written extensively about. The young of Shetland have a unique opportunity to develop their talents with the help of educational specialists such as Harry Rose of Shetland Field Studies (left).

In the field, aquatic bugs are all identified as an introduction to a world of nature unfolds in a plastic bucket. There are cetaceans and birds that seem to have us all hooked on an ever extending ladder of knowledge that will occupy more than our lifetime. We need experienced folk who can pass on all this information, so start them young and with luck our environment will also benefit from a new generation who really appreciate the world we live in.

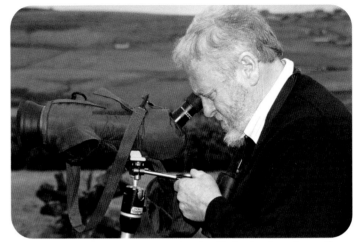

Maybe there's a budding Bobby Tulloch already well on the way to being able to pass on their enthusiasm for Shetland's wildlife in that very special and friendly way as only he could. Just how many of us can say we were influenced by him will never be known … but I bet you have all heard of him!

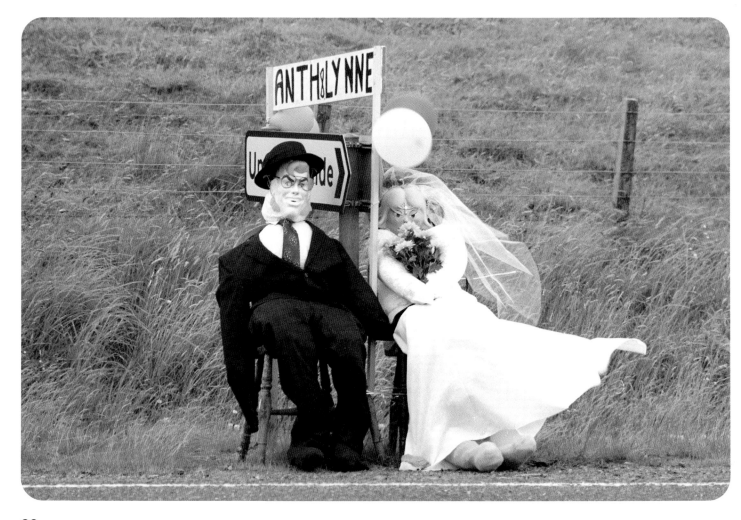

38

Shetland has characters...
some very special characters

Wherever you go throughout Shetland, you will come across some of the folk that have made a lasting impression on the whole fabric of the isles. Tom (below) must have many memories of times gone by sailing his boat across the North sea to Norway, he has done the trip some 39 times over the years. More recently his valuable time and experience has helped restore the beautiful *Swan* – a sail herring drifter from the past. Built in 1900, she is now back to her former glory making sail training trips around Shetland and far beyond. Tom is a navigation expert who has trained many a young mariner the precise skills needed to safely travel the seas of the world. If ever a man looked totally happy and at home on a boat it's Tom Moncrieff of Lerwick.

Shetland has many famous sons when it comes to music and they don't come more well known than Peerie Willie Johnson (below left). Having travelled to many parts of the world playing with all the stars and especially Shetland's own Aly Bain. Like most inspired musicians the essential refreshment can be found at the elbow when playing at renowned venues such as the Lounge Bar in Lerwick. This is still probably the place to hear Shetland's musicians at their best. A bar where just about anyone can turn up and have a tune.

Thinking of Willie's individual guitar style reminds me of a character and craftsman, Robbie Arthur (below right). If we knew enough about stone walls you would recognise his work as easily as a tune played by Peerie Willie. Robbie builds lasting works of art, his stone dykes will I'm sure be around for hundreds of years, lasting qualities just like the music of Shetland. Cherished reminders of time well spent.

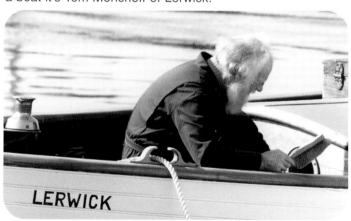

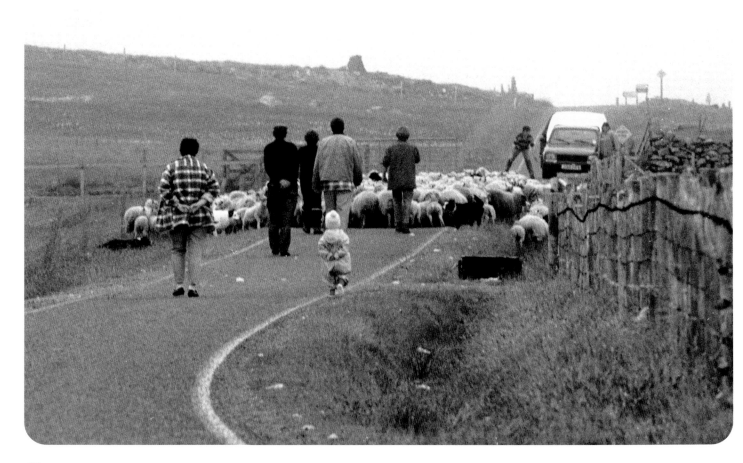

Crofting in the traditional way, regardless of the climate...

For crofters the good and bad times all add at the end of the day to little more than a dedication and love for the way of life. Gathering up the sheep is a family affair when all hands are put to good use. Teach them young in the ways of how to go about sorting the flock out or just enjoying the occasion if you have a little way to grow yet. What was a way of life long before the oil rich days came to these shores will hopefully be able to continue, but given the recent market of decline for almost everything that the crofter depends upon we may well see a diversification to other methods of earning a living. Many of today's crofters have other jobs to support themselves and it is sad to think that Shetland crofting may become little more than a hobby for most. Certainly the appearance of the old croft has almost gone, just try to find one to photograph. They are getting thin on the ground but

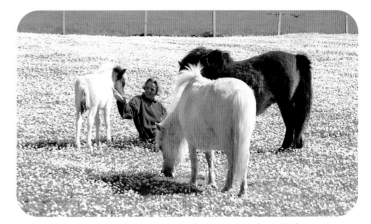

romantic scenes of days gone by can be found if you know where to look and you are fortunate with the weather.

Shetland ponies are always popular with the tourist and idyllic pictures are a real pleasure to see. Hopefully the Shetland pony trade will will not suffer in the same way the sheep farmer has recently. Its difficult to draw comparisons, but in the past we all said the Japanese motor bikes would never replace the quality made British one ... well today everything seems to be changing, not always for the better. How Shetland must have been some 50 years ago would drive any tourist boss of today to despair, the very thing folk want to see is fading fast. Fortunately the wildlife and scenery will play its part as it does for other countries and this is where some crofters may be able to provide the visitors with a reminder of how traditional island life used to be with the skills of generations being seen to work and work well even today.

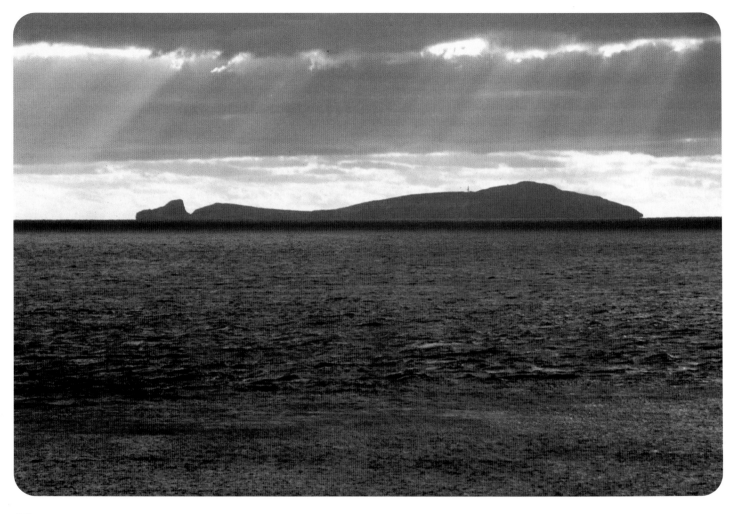

The light in summer is special.

Shetland has the most amazing light and for those who watch the sunset turn into sunrise during June, the experience can be magical. Colourful skies that defy description are there to admire as the shapes of the landscape are silhouetted and drenched in colour. Warm tones, crisp cool morning tones filled with mists and bird song. Without so much as a breeze to ripple the sea, every movement on the waters surface can be seen for miles. Peat smoke curls from a croft and wafts through the morning air to complete a perfect picture of a Shetland scene to remember. Where else can you sit with nothing but the buzz of a few really early insects and with no cars to be heard to spoil the peaceful effect. A man who enjoyed such times once said to me: "Some folk don't know what they are missing, by the time they get up the best time is long gone!" … Bobby Tulloch, who else!

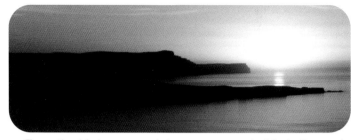

Even the birds seem a lot more approachable in the early hours, maybe, like me they are not fully awake and a sort of mutual trust exists. Anyone who's about at these times may feel they are at one with nature and I'm sure wildlife responds accordingly; until you try to capture it all with a camera and the mood changes as you become a hunter. Wild creatures still have that sixth sense and long may it last! Unfortunately often the best lighting effects are only a fleeting experience but if you are in the right place at the right time, it's all there for you to capture, to savour and best of all remember.

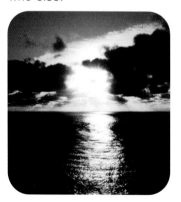 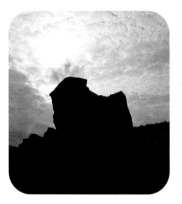

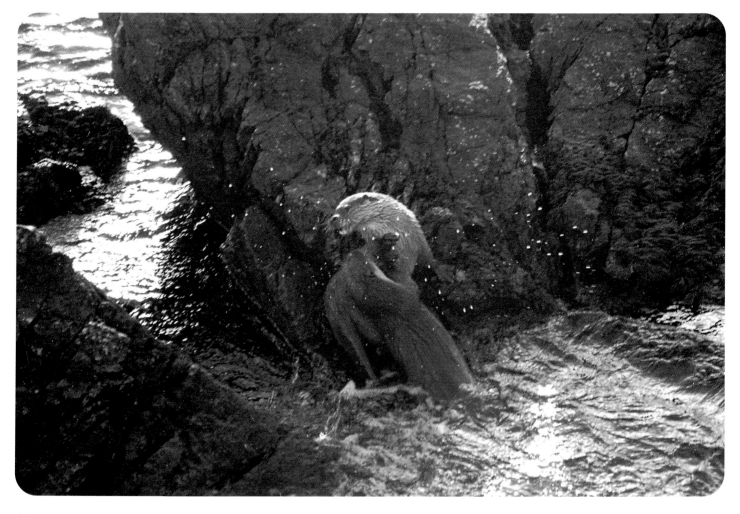

When it comes to photography, Shetland has all the challenges

All types of folk come to Shetland to try their hand at capturing stunning scenery and the many moods of the weather along with the splendid wildlife. Some bird photographers will spend all day trying to get a shot of the latest rare bird to turn up in the isles. A landscape or a seascape will need careful planning to get that special picture onto film.

Shetland has so much to offer the visiting snapper or keen amateur and if in luck, one or two real surprises. Killer whales at Sumburgh, otters curled up asleep on the tide-

line, picture postcard pony shots until you run out of film and all this in a Shetland landscape that can look stunning or stormy within the space of an hour or two. Try a sunrise, this is when the real Shetland can be experienced in all its glory.

Expect the unexpected certainly applies to these shores, as every corner turned on a quiet country road can produce a once in a lifetime chance encounter, there for the taking.

Peaceful sandy bays, dramatic rocky headlands or hardly visited hilltop lochs amidst typical boggy flow country. Spring and summer are really beautiful times with plenty of the blue skies and beautiful crofts. However try for the wilder side of Shetland life and you will have some dramatic studies of the real forces of nature at work. If you have never taken a photo in a force 10 gale, have a go. The wilder the better, soak it all up but most of all enjoy your Shetland photography experience, wet or dry! When you visit Shetland you will find time is the problem, there's so much to see and do that the long daylight hours of summer will be very welcome.

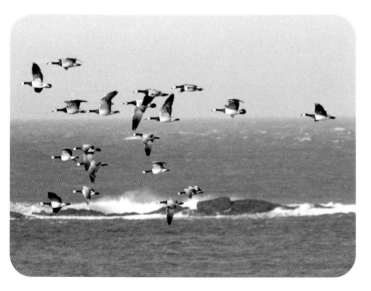

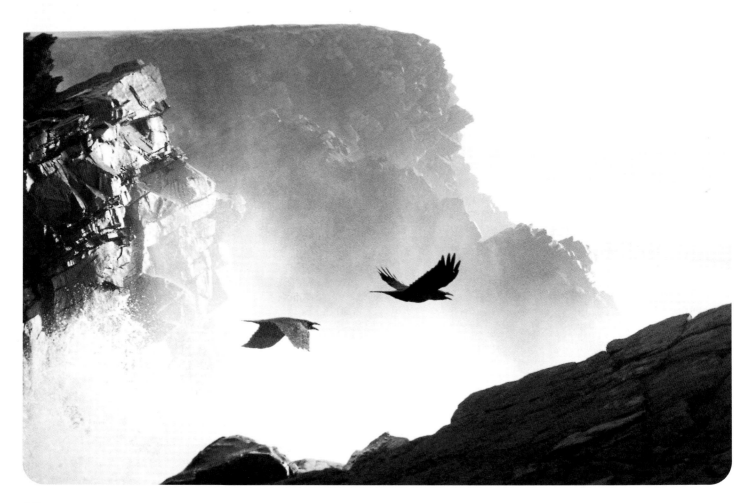

If it's the amazing wildlife that brings you to Shetland...

You will not be disappointed as these shores can boast some of the finest otter populations and cetaceans that can be found anywhere in Britain. If you are an experienced field worker or just an interested visitor there's scope for all.

Some birds may be on the decline on the mainland but here in Shetland we are really fortunate in having farming and crofting systems that still support the birds in a way that we can remember our fathers talking about.

One bird unfortunately has really expanded over the years, to the detriment of a number of other breeding Shetland species. The bonxie, or great skua to give it its correct name, (I won't go into what most crofters call it), has in years become a real nuisance. Quite large colonies of these protected species are doing untold damage to other birds such as the eider, Arctic and common terns as well as other sea birds, and probably no nesting species is safe from attack. If only they would stick to rabbits!

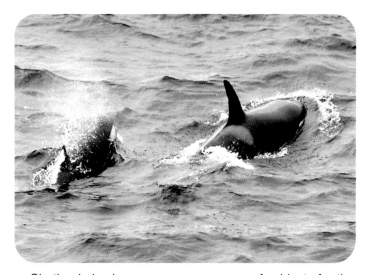

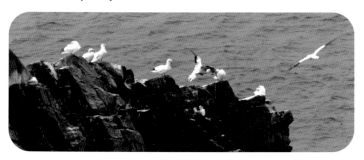

Shetland also has an enormous range of subjects for the naturalist to study and with lots of plants to excite the resident or visiting botanist. You may even be lucky enough to discover a new plant species for Shetland; but as Walter Scott of Scalloway has covered just about every inch of the isles, you will be very lucky indeed. The flora and fauna of Shetland has been carefully recorded in a number of natural history publications and with ongoing scientific surveys taking place annually we are fortunate that these dedicated folk brave all weathers to study our wildlife. Changes can be due to something more subtle than an oil spill! It's these specialists who will notice anything going wrong. We may not like it, or be able to do anything about it ... but at least, we should be well informed!

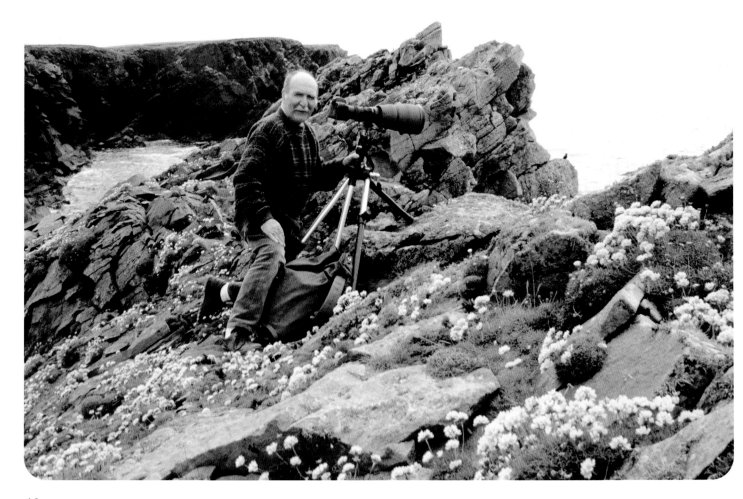

Wildlife photographers enjoy Shetland's opportunities.

Just about every wildlife photographer has at some time arrived in Shetland with great expectations. Some are looking for the chance to get shots of a rare bird that has eluded them for years. Others are far more interested in getting their subject along with a fair lump of the scenery to accompany it. One or two of the best live right here in Shetland and spend countless hours in pursuit of the perfect picture.

Brian Chilton (left) certainly got me interested in photographing otters, his dedication never wavered and he would be out be and about in all weathers after the elusive otter. He reckons January or February are the best times, but they also happen to be the worst months for bad weather, so you have to pick your days. Intimate shots along a rugged shore, close ups of sleeping cubs, he's done it all and until he left these shores after some 25 years or so I would have said he was one of the best living here.

Other keen photographers come for the breeding birds and try to get an unusual angle on the way they fly or can be

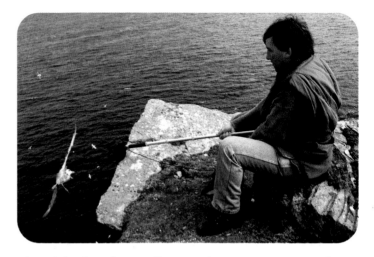

another wildlife photographer...
boring, boring, boring

placed in the picture. One southern camera man, Steve Knell (above) had a new angle on this as I met him on Noss trying out the idea. A wide angle lens, remote release and a boom. A method of getting close ups of the Fulmars with a backdrop of landscape. I would like to see the results as it was difficult enough for me to time the birds passing near to his camera. Rapid reactions and split second timing would be called for I'm sure, hopefully all his efforts worked to achieve something really quite different.

Shetland has as many subjects as any wildlife photographer would need in a lifetime. Wildlife rarely assists the photographer in his efforts to capture anything half decent on film. I always count a good shot as a bonus to the experience and sheer enjoyment of watching nature in the raw ... however cold you can get waiting for the shots.

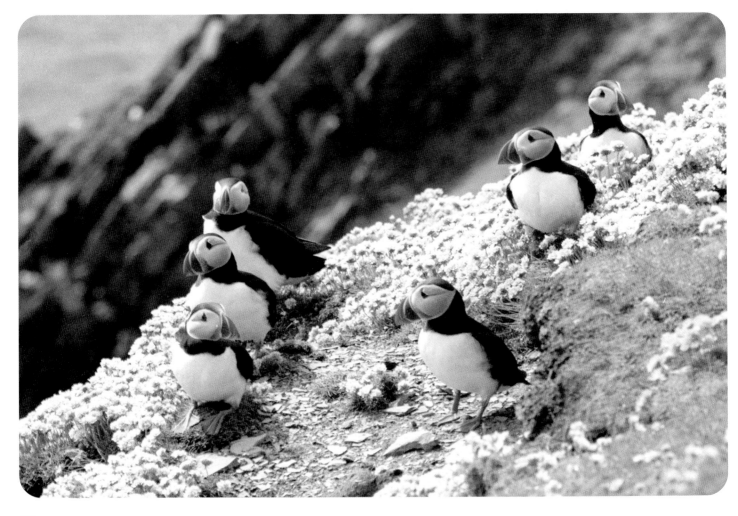

The comical puffin will have you coming back for more...

Sumburgh Head, Noss and Hermaness puffin colonies are a big attraction for the visitor to Shetland. They are fairly small as sea birds go but will have you engrossed in their antics and growling calls. Puffin nest in burrows and once a nest is occupied the male will stand guard at the entrance when it is not fishing for the sitting female, or at a later stage for the ever hungry young.

At these colonies one can almost sit amongst them, allowing you the opportunity to take photos that you had only seen previously in books. Hopefully there will be some sunshine to brighten up their plumage but watch the contrast they can be tricky to get right, generally it's just light and luck, so give it a try – it may be you that gets lucky.

They are very approachable and as long as you take care many a film will be filled with photos full of expression and action. Wing stretching, posing with a beak full of food or just yawning, the adults do seem to get a little bored at times. With the thrift in full bloom, a backdrop of the cliffs falling away to the sea and a gathering of puffins a colourful picture that would be difficult to beat as a reminder of your trip. Flight shots are a different thing altogether as puffins are incredibly fast flyers; best to catch them in the updraft as they come to have a look at you.

At Sumburgh Head the RSPB have an office and information display boards during the breeding season. These are well illustrated making identification of the various birds a simple task. No one can mistake the puffin for anything else though, and if, like me, you run out of film whilst trying for that very special shot, remember there may be lots more appealing puffins just around the corner, so be warned because puffins eat film for breakfast, dinner, tea and supper!

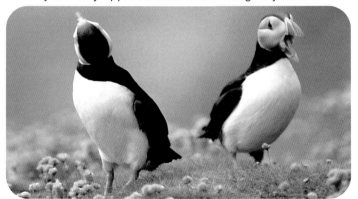
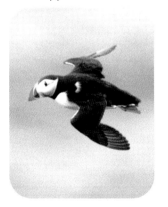
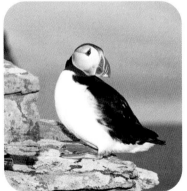

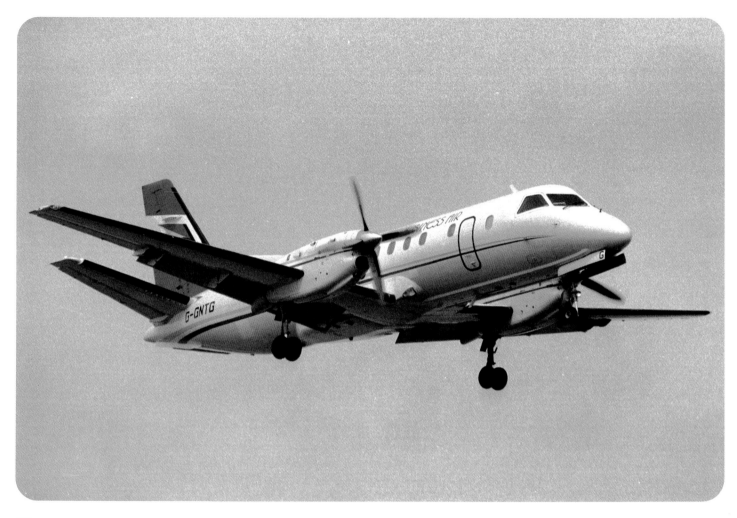

Arrivals by air come in all shapes and forms...

The main airport at Sumburgh sees many different types of aircraft from all over Britain and Scandinavia, and even some from further afield. Often strong winds can make a safe landing almost impossible, but it's the dreaded fog which can bring everything to a standstill, leaving frustrated passengers sitting around for seemingly endless hours. For those coming in to land the last thing you want to hear from the pilot is "we will circle once more!"

On the other hand, there is nothing better than coming in to Shetland on a really clear day and having the wonderful scenery unfold below you. Fair Isle, the lighthouse and a rather rapid drop to the runway over the farm can be quite exciting. You have landed, this is it … Shetland.

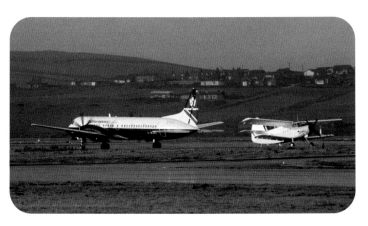

By air there are other visitors that have come from very much further away, long travelled birds that have flown from the other ends of the earth.

Arctic terns annually return to these shores in order to breed and rear their young for a few months before they make the return trip south. Many thousands of miles are clocked up without an airport tax, warning light or a free drink to hold up their progress. Arctic terns travel many thousands of miles annually, so it's no big deal flying up from Aberdeen.

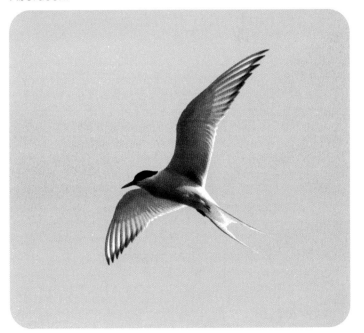

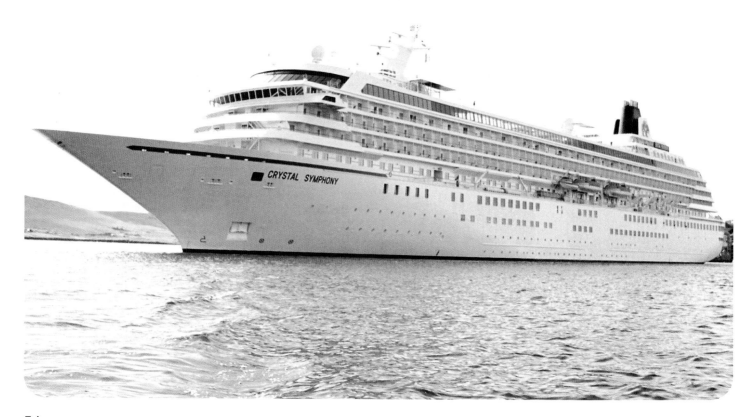

Arriving by sea can be in many different ways...

When folk arrive by sea the they must notice the many different types of boats that are in the harbour or passing the isles. Beautiful cruise liners and oil related vessels are a common sight. One memorable craft in particular was the gigantic lifting crane that anchored off Trebister dwarfing the *St. Clair* as she passed en-route south.

Ferries of all types ply back and forth to the many islands, most are roll-on, roll-off boats but other methods are needed to get your car to Fair Isle on the *Good Shepherd IV*.

Classic boats can arrive at anytime giving the harbours an appearance of sailing times gone by. A harbour full of old fishing boats would be a sight.

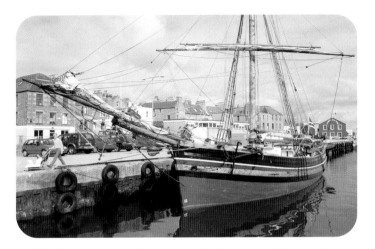

Worlds apart but built to cope with the sea in all its moods.

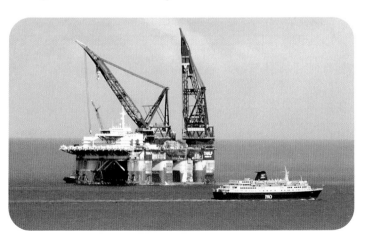

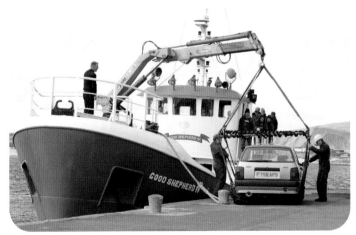

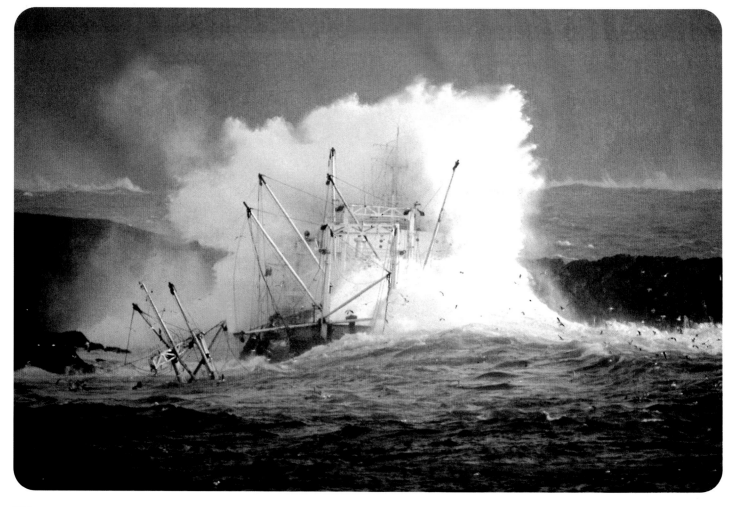

Shetland has bad weather...

For anyone who has visited Shetland and had the fortune to be blessed with good weather here's a reminder that we do have the real thing when it comes to storms. A fish factory ship of some ten thousand tons was driven onto the rocky headland at Trebister Point in full view of Gulberwick residents.

The *Pionersk* came to grief during a severe south-easterly gale in December 1994. With a grandstand view from our window, the sad sight of such an event really brought home the risks involved for all seamen during these times. Fortunately, thanks to the rescue services, no lives were lost, although the rescue operation was made more difficult by the fact that the *Pionersk* foundered around midnight and in total darkness.

Locals feared a massive oil pollution problem on the nearby beach at Gulberwick, but despite the fact that loads of wreckage by way of herring barrels and vast amounts of wood washed ashore, luckily very little oil arrived.

The initial threat to bird life rapidly turned to a feeding

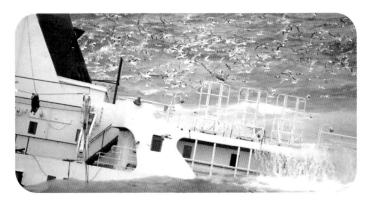

bonanza for the thousands of sea gulls that filled the skies to take the bounty that spilled from the stricken ship. For many weeks, birds of all species had their daily supply of fish with each huge swell that forced the cargo back to the sea. It is said that the sea always gives up what it doesn't need, well ... Gulberwick beach was a real disaster area for weeks as locals made its clean-up a daily task after each tide brought ashore a mountain of wood and debris.

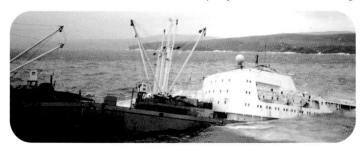

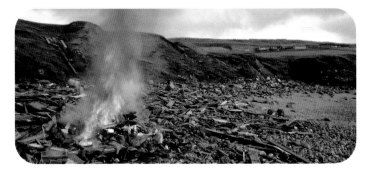

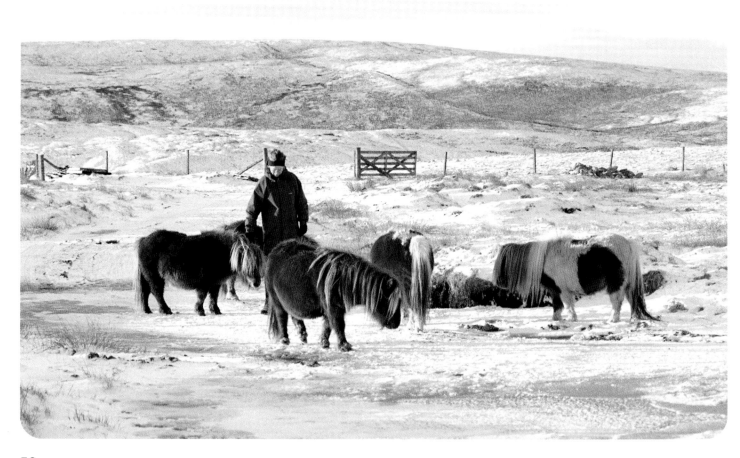

Shetland ponies are real tough characters...

For most of the year the tough little Shetland pony will be on the open hill and seem to be able to take all the elements in their stride. From the warm balmy days of summer to the most biting winds straight from the north, they just put their backs to it and no doubt think of happier times. They revel in the cold bright wintery days up on the hill tops and will follow the walker with interest, maybe for company or to see if there's a bite to eat forthcoming. You can't help admiring these characters and their appearance, its no wonder that Thelwell's drawings of the Shetland pony are so popular, especially with little girls. Every one of them wants one to pamper and cuddle up to, but the fact is they are where they like to be, on the hill in the open and amongst each other for company. Just look at how well they survive. They almost look out of place anywhere else and lose something in a paddock or tree lined field down South. The Shetland landscape is richer for having these rugged animals in the wild, the wilder it is … the better they look.

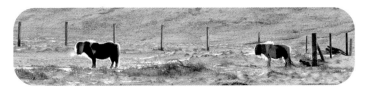

There must be times when a shelter of sorts would help, a wind break at least, but they get by on a daily visit with food and drink to supplement their harsh conditions. As far as being photogenic … ever seen the countless bus loads of visitors at the roadside filling films with the most beautiful pony picture of all? Fields full of wild flowers, sweet grasses and blue skies. Far removed from the days to follow with rain, snow and low temperatures we wouldn't last a night in. This is what gives the Shetland pony its real strength and charm as a totally adaptable animal that reflects the environment in all its many moods. A real long haired Shetland character with a lengthy pedigree to match.

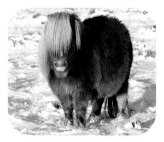
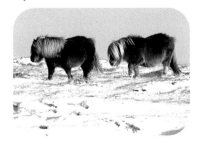

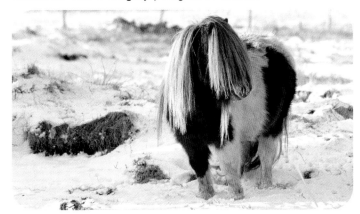

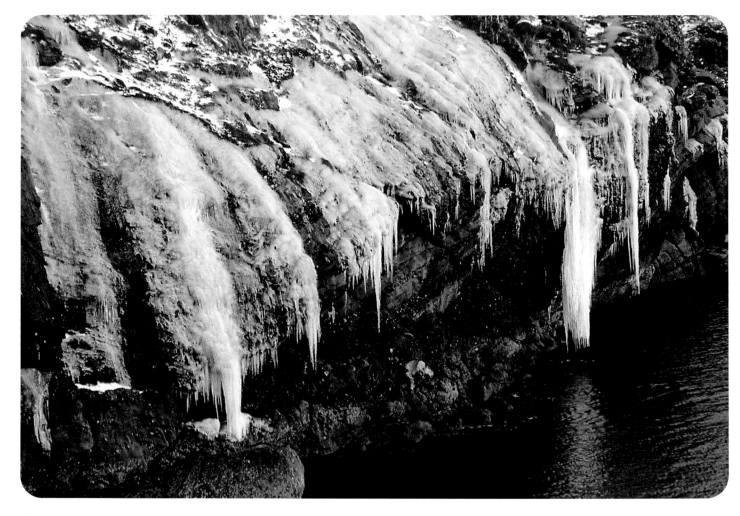

Shetland can be cool, very cool when it likes...

The weather here in the northern isles can vary from one extreme to another in no time at all, but some winters just seem to go on and on with no let up in conditions once a pattern has set in. Huge icicles formed on Trebister point one year and continually dripped into the sea with points being washed and rounded off by high tides. At about 10-12 feet long this impressive sight lasted for several weeks until eventually the cold northerly winds swung around to the south-east and the whole effect of a dazzling cliff face soon returned to the dull bare rocks once again.

This was a fine example of natures art at work with all the elements playing their part. Created by the elements and destroyed by the same, in a matter of days it was history.

Bird life has a very difficult time during these spells and once the ground is really frozen there is nothing for it but to head for the shoreline for sustenance. Even the fresh water loving swan has to take up residence in the voes until it warms up and the frozen lochs melt. Beautiful to look at but it does not mix very well with wildlife.

Determined whooper swans check out the conditions of a loch only to find the thin skim of remaining ice still prevents them from returning to normality. Within a few days the pair were gracefully swimming freely in their watery habitat and obviously like the rest of us pleased to feel a bit of winter sunshine on their backs. Garden birds also find it almost impossible to obtain a drink or bathe in fresh water during frozen conditions and every help by way of providing this vital necessity for them would ensure that they will survive the tough times. A blackbird shelters in a foot print out of a biting wind, enjoying a spell soaking up warmth from a low winter sun. The sea gulls decide to sit it out on a well frozen Pullars Loch until the tide recedes and they can feed along the shore once again.

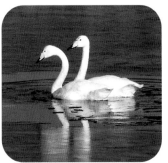

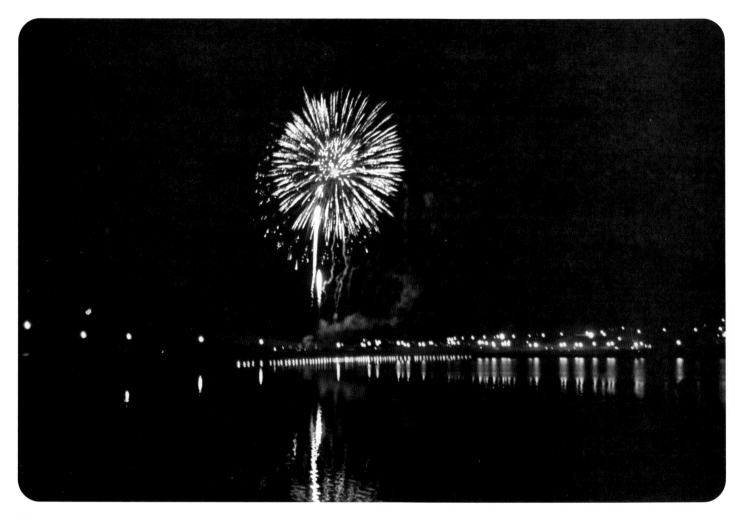

Thousands of folk attend the fireworks display at Clickimin Loch and it goes with a bang...

Huge crowds gather around the loch side in November to enjoy a display that more times than not has a dry evening. It has been known to rain for days before the event only to clear up hours before. This well organised fireworks display has the added advantage of being reflected in the water, with the silhouettes of the ancient broch making this quite an exciting and unique experience. It all starts with a very the loud bang from a maroon set off a few minutes beforehand.

Music plays throughout and compliments the whole scene, this can largely depend on the strength and direction of the wind. This also has an effect on the fireworks and can make very dramatic trails from the star bursts as they stream away through the darkness. Children mingle with the crowd wearing vivid fluorescent head bands or waving chemical glowing wands and multi coloured fibre optic whips. With the last of a bonfire being blown almost flat in the gale.

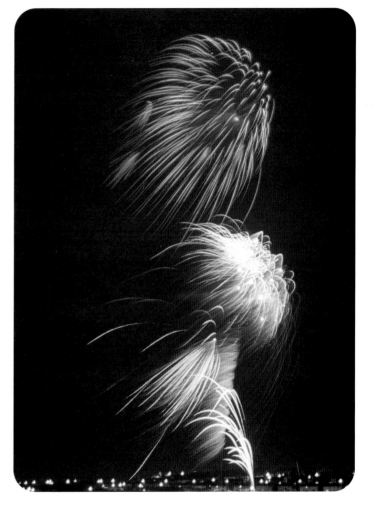

63

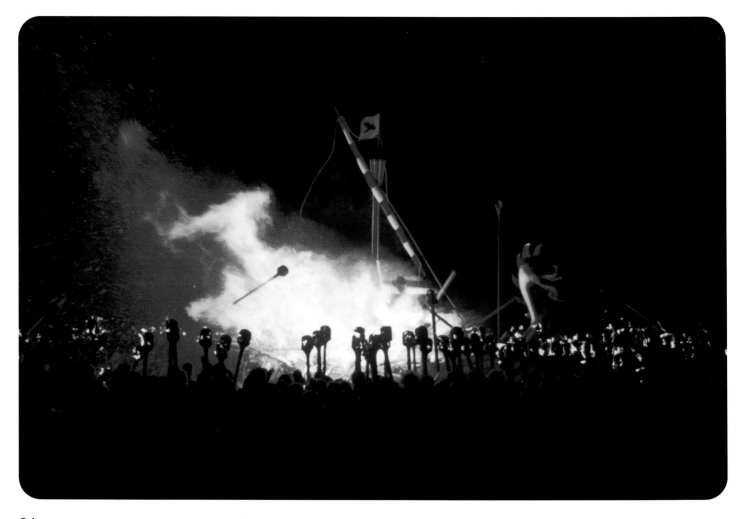

One day when I grow a wee bit I will be the Guizer Jarl...

Who wouldn't want the real honour of heading the torch lit procession of a thousand guizers in the Lerwick Up-Helly-A'. Singing as they wind their way around the streets with the Guizer Jarl aboard the galley surrounded by his squad of Vikings. Cheering crowds line the streets as the parade makes its way to the park for the ceremonial burning. Torches are flung into the galley which lights up the night and warms the huge crowd of locals. Thousands of folk attend the various halls in the town after the burning and festivities go on right through the night with music, drinking and dancing. A night to remember, once you can all find your way home in the morning that is!

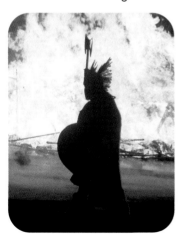

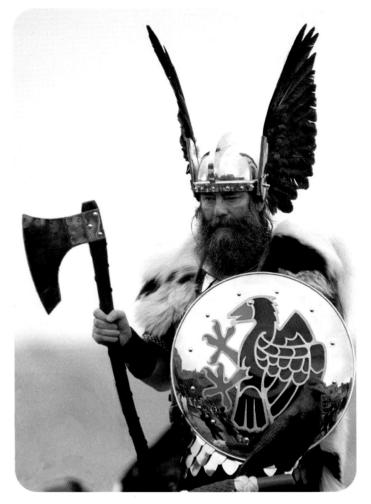

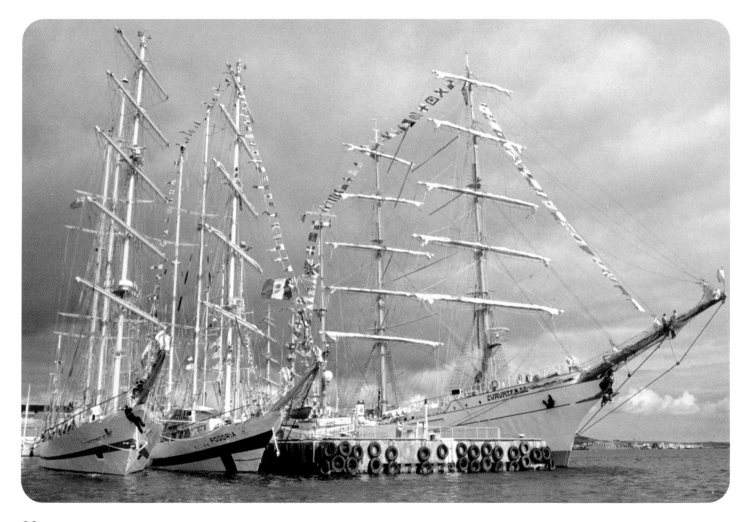

Shetland hosts the Cutty Sark Tall Ships in style...

The world's largest sailing vessels called in to Shetland in August 1999 and the scenes of Lerwick harbour full of these splendid ships will be remembered not only for the atmosphere, but for the unbelievably good weather. Crews of all nations enjoyed the hospitality of a friendly port and joined in the lively party atmosphere for the four day stop off. With around 2,000 crew members and visitors over the 5,000 mark, the town of Lerwick was a bustling port for the week. Colour was the most memorable impression of the whole event. Smiling faces and a mixture of languages were to be seen and heard all over the town and especially at the tourist office enquiring where to go and what to see. With many organised events and tours around the islands there was plenty to keep everyone occupied.

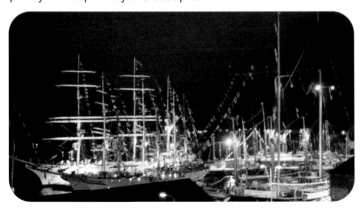

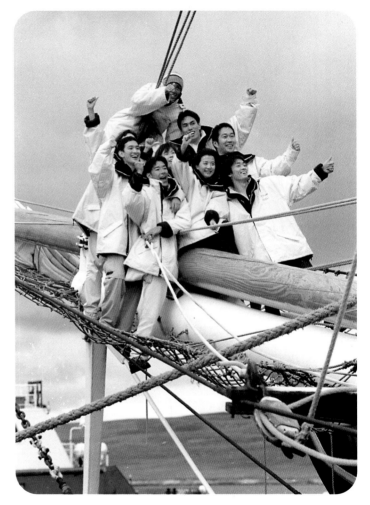

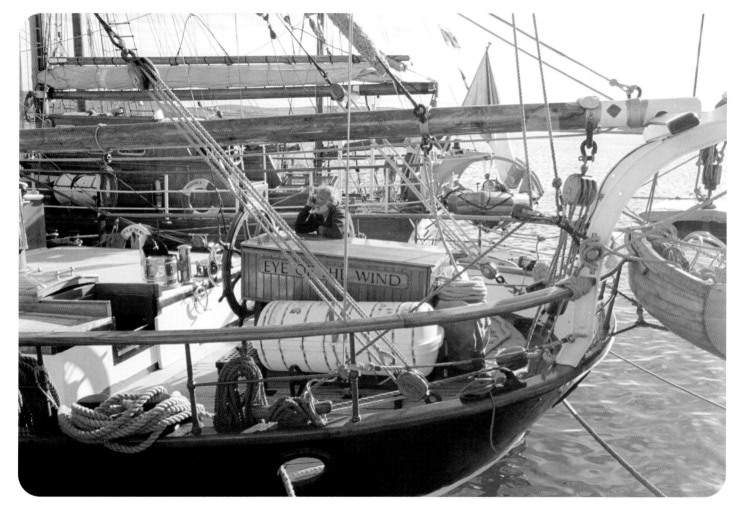

The finest tall ships were dressed for all to appreciate...

No one could resist the classic lines of the huge sailing ships especially when you have a trio of them tied alongside the dock at Holmsgarth. The work of the crew continued as everyday duties were carried out. On arrival paint work was seen to, as well as dressing the boats out with flags, lights and buntings. Individual ships had their own style of making a nautical statement. Some of the larger vessels were well rehearsed in presenting the very best image, with attention to detail and all the finishing touches to their vessels were done before before the big Shetland party began.

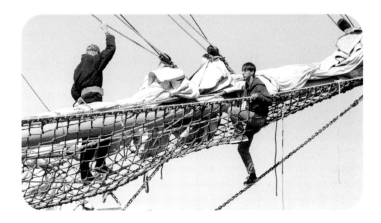

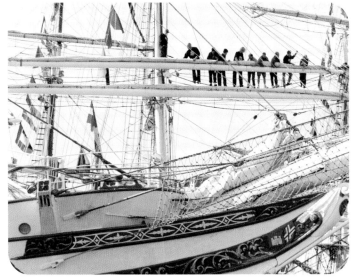

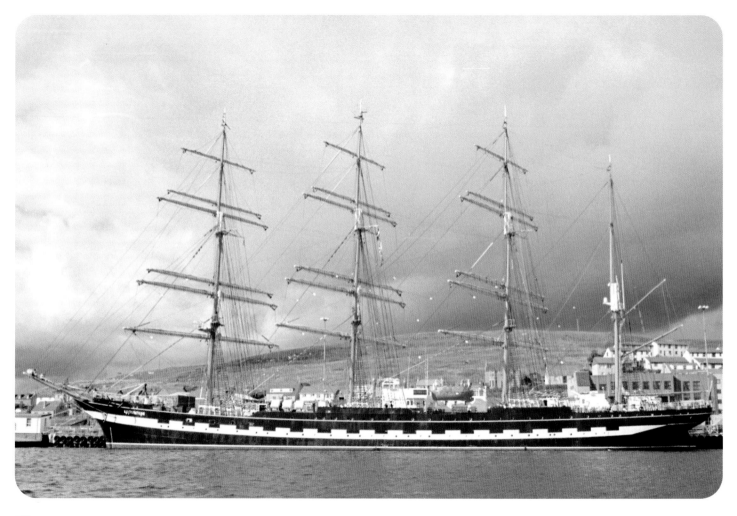

70

The local classic sets off ahead of the big boys...

The beautiful *Swan* sails in very good company as she sets out bound for Denmark ahead of the world's finest tall ships. A real spectacle that local folk will remember for many years, in fact till the next time the race visits these shores. The crews are well drilled in the art of sailing and to see the larger ships prepare to go to sea was a treat. The Mexican crew from the barque *Cuauhtemoc* stole the show for many with their style, manners and hospitality that was shown to folk during their stay. A real boat was *Eye of the Wind*, a classic and with no effort spared in her meticulous attention to detail. Another fine example was the *Alexander von Humboltd* (below).

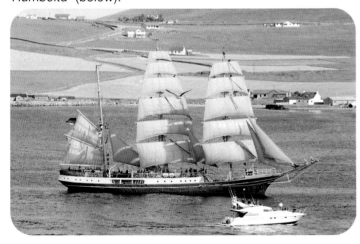

All too soon they were away as the final leg of the race began in perfect weather, the spectacle of a lifetime was viewed by thousands at every vantage point from Lerwick to Sumburgh.

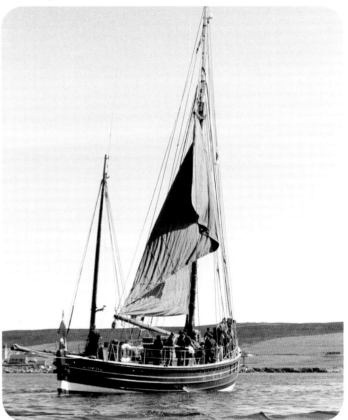

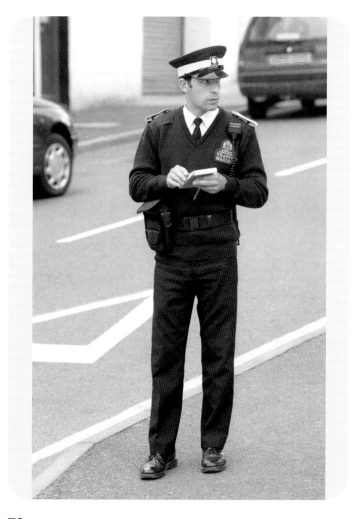

We hope you enjoy your stay in Shetland... **however short!**

There are hardly any traffic problems to speak of compared with the mainland, except sometimes in the town of Lerwick, where parking can be a little strained. We really are fortunate in having a friendly but fair traffic warden to keep the situation under control for the benefit of us all.

Yes, that's me on the double yellows again!

Bill Jackson, Gulberwick, Shetland 2000.

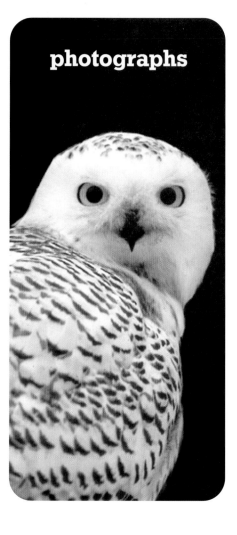

photographs

Front cover: Martin Adamson at Grutness. Intro: Sunrise from Rafns, Gulberwick. **4** Winter snow, Gulberwick, **5** Wildlife and Gulberwick locals coping with winter. **6** Ivory Gull, OIL Base, Lerwick. **7** Rare gulls, laughing, Ross', ivory, Glaucous, ring-billed and little. **8** Bess Jamieson of Walls, weaving. **9** Yoal building tools, Kishie and tools, Peter Manson, making spinning wheels. **10** Anne Eunson, spinning at the croft museum. **11** Kathleen Anderson, Debbie and Cob web lace knit shawl. **12** Norwegian visiting yachts, Lerwick. **13** Norwegian motor cruisers, Lerwick. Traditional dresses and sail repairs around the harbour. **14** Photographer Malcolm Younger and dingy racers, Lerwick. **15** Photographer Dennis Coutts. **16** Fiddle maker, the late Peter Gray of Lerwick. **17** Skyinbow electric fiddle and maker Kenny Johnson. **18** MG Sports of 1932. **19** A selection from the Classic Motor Show. **20** Twitchers at Asta. **21** The blue-cheeked bee eater at Asta. **22** Fly tying materials **23** A trio of wild Shetland brownies, 100 year old flies, BJ trying for a sea trout. **24** Yoal builder Tommy Isbister. **25** Old working boats on Foula and Fetlar. **26** Brough Lodge, Fetlar. **27** Golden plover, red-necked phalarope and red-throated diver. **28** Red-necked phalarope at sunrise, Funzie. **29** Film crew working on Bill Oddies TV bird series, Fetlar, red-necked phalarope taking emerging insect. **30** Durigarth crofters harvesting. **31** Starlings on stooks, bobolink feeding and crofters harvesting on Out Skerries. **32** Peat gatherers taking a break. **33** Cutting the peats at Swinning, whimbrel, redshank and great skua. **34** Geordie Jacobson with a dream machine at Vidlin. **35** Bikers meet at the Thule Bar, local bikers Mullay and Wishart, powerful lines of a beast at Vidlin and a row of mean machines. **36** Harry Rose with Walls school children. **37** The late Bobby Tulloch, MBE, large white butterfly, young hedgehog, goldcrest and hummingbird hawk moth.

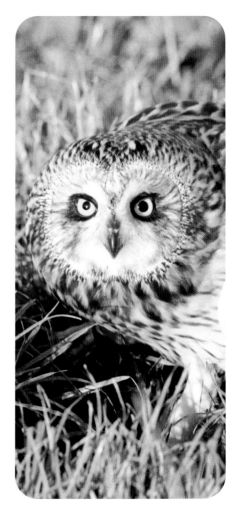

May I take this opportunity to thank Fiona
for all her patience and help in making this book possible.
Also my friend Davy Burrows for casting a careful eye over my proofs.
Not forgetting a big thanks to all the folk who allowed me
the time to photograph them at their work and
especially to those who did not even know I was there.

My sincere thanks, Bill Jackson.